T0054747

ABC MIRÓ

ABC MIRÓ

MAR MORÓN
GEMMA PARÍS

GG Los cuentos de la cometa

This book was made possible through...
the richness of Joan Miró's work,
the generosity of Successió Miró,
the expert assistance of Jordi Clavero and Montse Quer of
the Fundació Joan Miró's Education Department,
the support of Rosa Maria Malet, Director, and Dolors Ricart,
Deputy Managing Director, of the Fundació Joan Miró of Barcelona
and the work of the entire team at Editorial Gustavo Gili,
and in particular, the expert and keen eye of Mònica Gili.

To...
Begoña and Carlos, who taught me how to fly.
Teresa, my family and friends with whom I have shared so much.

And to...
Teo, Eric and Guillem...who discover new words and shapes
everyday;
Marc, with whom I share this adventure in education;
My parents, who accompanied me throughout this long
journey in reading, writing and painting.

Text and graphic concept: Mar Morón and Gemma París
Layout: Toni Cabré/Editorial Gustavo Gili SL

All rights reserved. Any form of reproduction, distribution,
public transmission or transformation of this work may
only be undertaken with the authorization of the copyright
holders, legally constituted exceptions aside. If you need
to photocopy or scan any part of this work, please get
in touch with the Publisher. The publisher makes no
representation, express or implied, with regard to the
accuracy of the information contained in this book and
cannot accept any legal responsibility or liability of any
errors or omissions that may be made.

© of the text "The Painted Word": Jordi J. Clavero
© of texts: Mar Morón and Gemma París
© of the English translation: Lola García Abarca
© of Miro's work: Successió Miró, 2014
© of the English edition:
Editorial Gustavo Gili SL, Barcelona, 2014

Printed in Spain
ISBN: 978-84-252-2735-6

Editorial Gustavo Gili, SL
Rosselló 87-89, 08029 Barcelona, Spain. Tel. (+34) 93 322 81 61

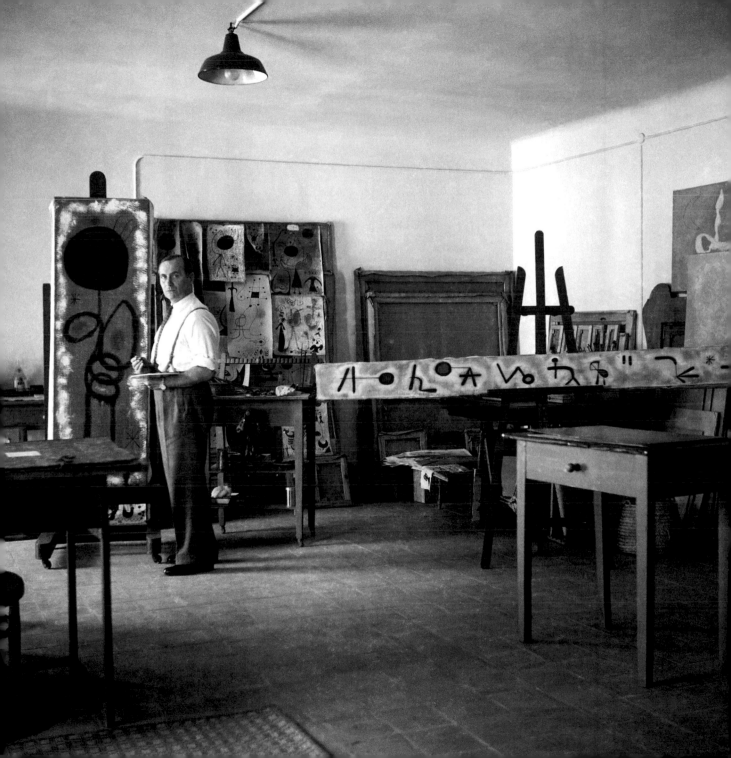

The Painted Word

In an interview with Miró in 1978, the artist remarked: "The simpler the alphabet, the easier it is to read." Of course the notion of what exactly constitutes "simpler" is, like most things, not as universal as one might think.

Developed gradually over his long career, the concise language used by Miró featured simple forms and perhaps this is why he was convinced of its simplicity. While the number of terms used by Miró was known not to be very extensive, they are characterised by great flexibility. For instance, the concepts of "bird" or "woman" — in and of themselves generic ideas — take on a multiplicity of meanings in his work. These elements could also be combined in an infinite number of ways, just like the letters of the alphabet can be put together in written or spoken form according to a given linguistic convention.

Nevertheless, on its own a single word says little, if anything, to the reader or listener. A word needs to be accompanied by other words. And much the same happens with a single letter, an object, or a representation of an object bereft of context. Without context, words, letters or images have no meaning.

And what happens if a letter is associated to an image? The letter then evokes, denotes, and seeks out some connection, a dialogue with the image. Yet it is clear that an image contains more information than a mere letter: a letter is miserly, limited; it is merely a sign that represents a sound, whereas an image is expansive, it opens up and establishes a scene. In short, a letter is nothing much on its own — just like a spark or a thread — but when coupled with an image a letter can lead to a world filled with ideas and emotions. "A piece of thread," Miró used to say, "can unleash a world."

Jordi J. Clavero
Education Department
Fundació Joan Miró, Barcelona

Figures and Moons...

... stars, birds, and a million other objects pervade the work of Joan Miró. The artist combined colours, textures, media, forms, techniques and formats to represent both his inner world and the world around him; he was a wizard who transformed basic forms into magic potions.

The idea for this book arose from a desire to bring art to curious hands itching to touch everything, to discover the world, to put a name to things and draw them. Learning to read and write is part of our process of learning and augmenting reality via our imaginations. But learning also takes place when we shape things, when we imagine them from different perspectives, when we realise that a single image is not worth one, but a thousand words, and that images are also created from each individual's experience. Representing the world, observing it with curious eyes, capturing the myriad of registers which modulate forms, mixing outer reality with emotions, taking that same moon we see every night and drawing it time and time again – all of these acts are the acts of the artist, acts which Joan Miró delighted in throughout his long career. And this too is what children love to do in their constant learning and their inherent desire to discover: they need to investigate the objects around them, imagine scenes, draw that one idea over and over again, an idea which develops over time to explain their perception and representation of their changing world – a world that lies somewhere between the real and imaginary. If Picasso said every child is an artist and that the real problem was how to continue being an artist when one grows up, then perhaps we should take down the barriers that separate the artist's world from the world of the child, as both realms share processes, successes and the desire to discover new things. We all need to continue being artists, to foster the investigative and enterprising spirit of our childhood; to allow our creativity, imagination and sense of wonder to continue being the main forces in our lives; to build our knowledge of the artistic heritage offered by our museums and incorporate it into our imagination; to encourage that desire to decode the meanings and emotions of the work of Miró; to establish an inner dialogue with a work of art; to come to the realisation that our world can be explained or understood from different points of view and from our subjective experience; to fearlessly experience the techniques employed by artists, giving new forms to ideas and feelings, and that the many artistic languages serve as tools in our quest for personal expression and a greater understanding of the world.

ABC Miró is for all those who are interested in and curious about art and reading, heritage and culture, imagination and creation. This book is for people who, in some form or another, continue looking at the world with the eyes of an artist when they grow up.

Mar Morón and Gemma París

ARROW

arrow

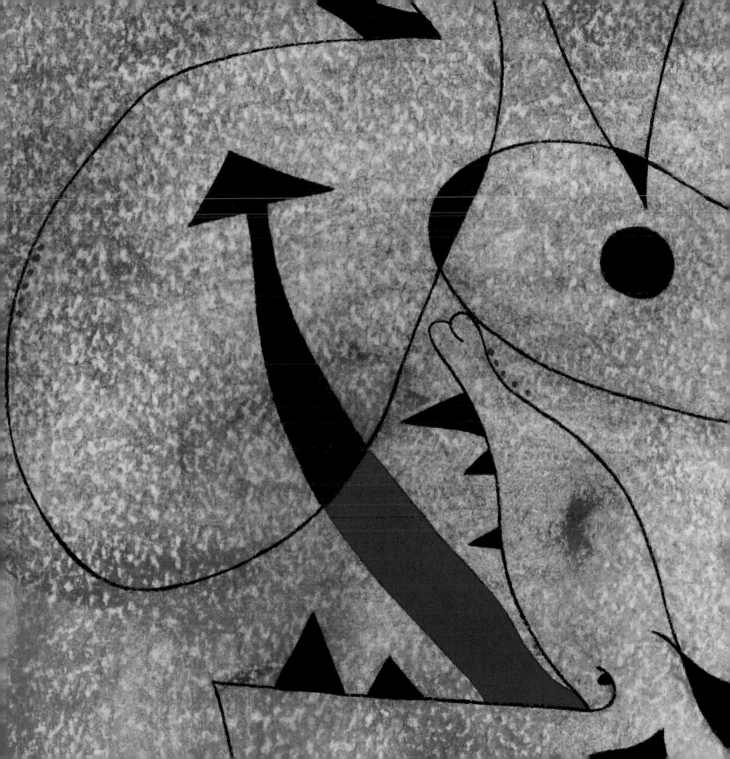

B

BIRD

bird

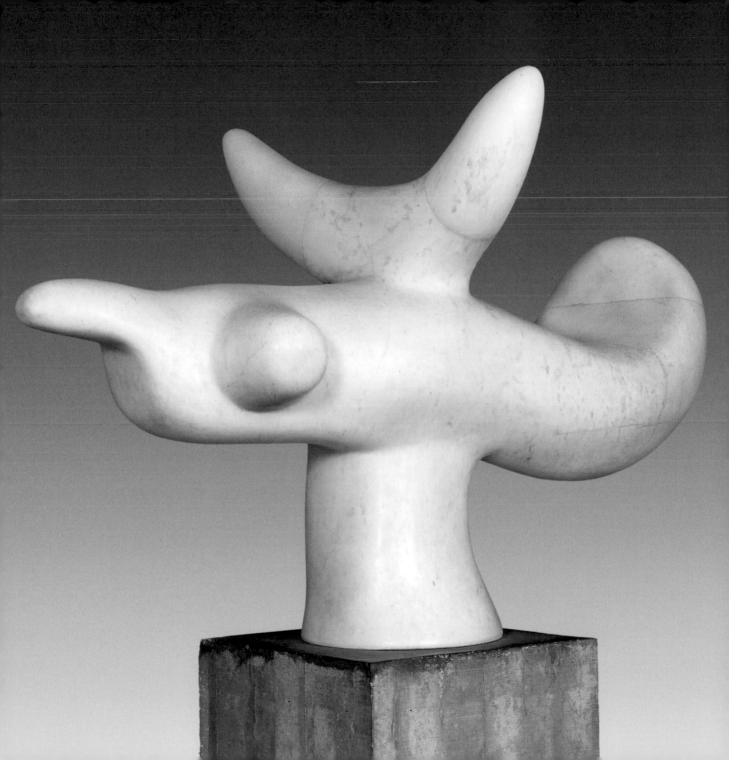

C

CHAIR

chair

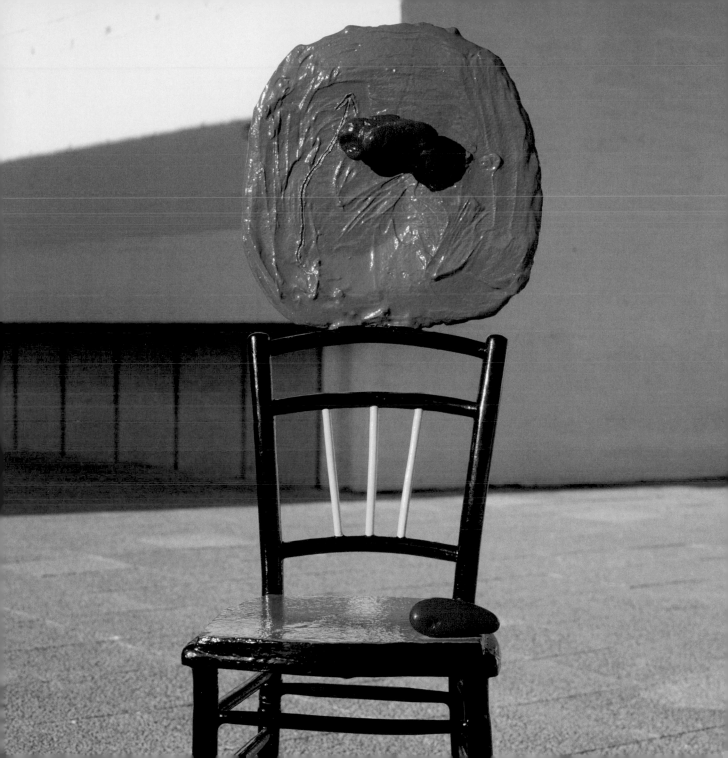

DRAWING

drawing

l'oiseau se lance vers l'...

EYE

eye

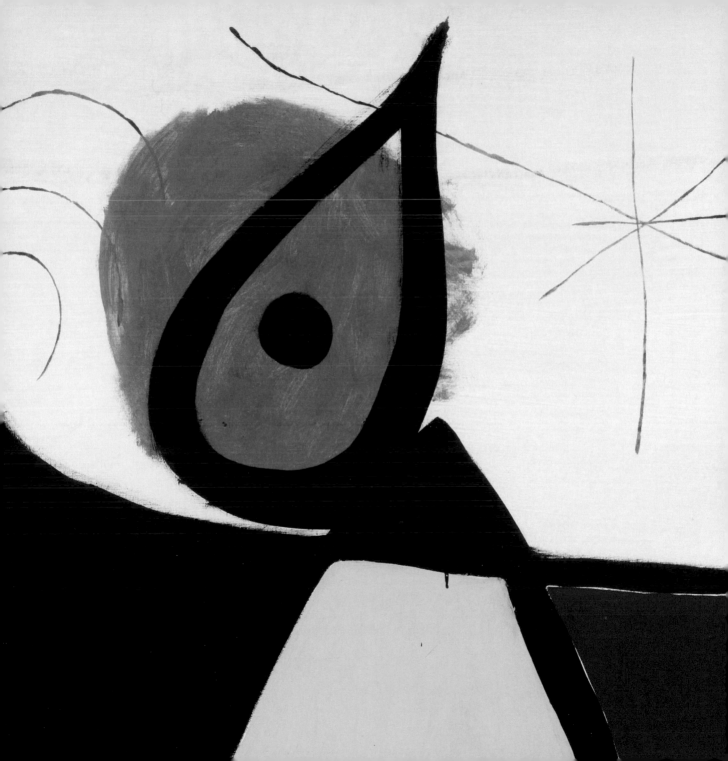

FACE

face

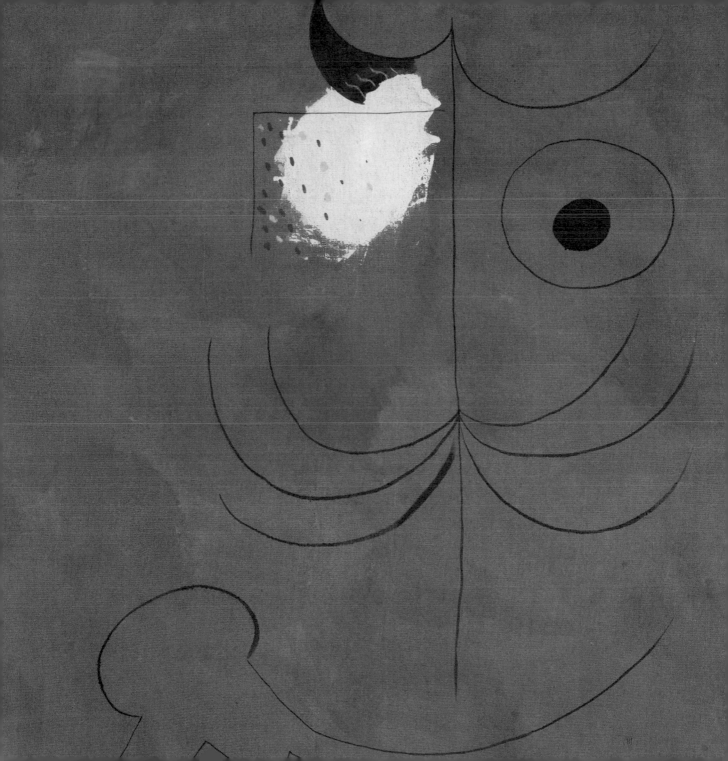

GIRL

girl

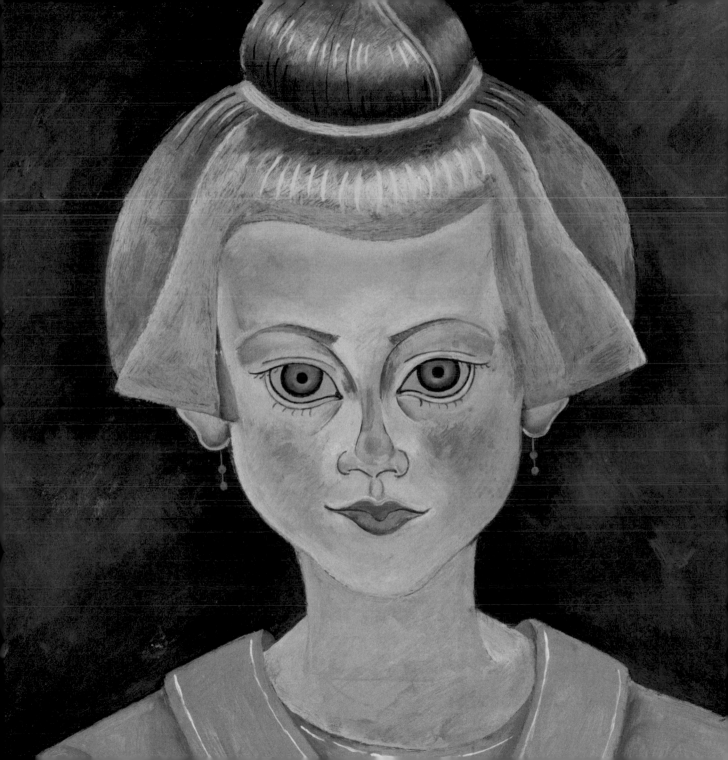

HAT

hat

INSECT

insect

JOAN

joan

K

SNAKE

snake

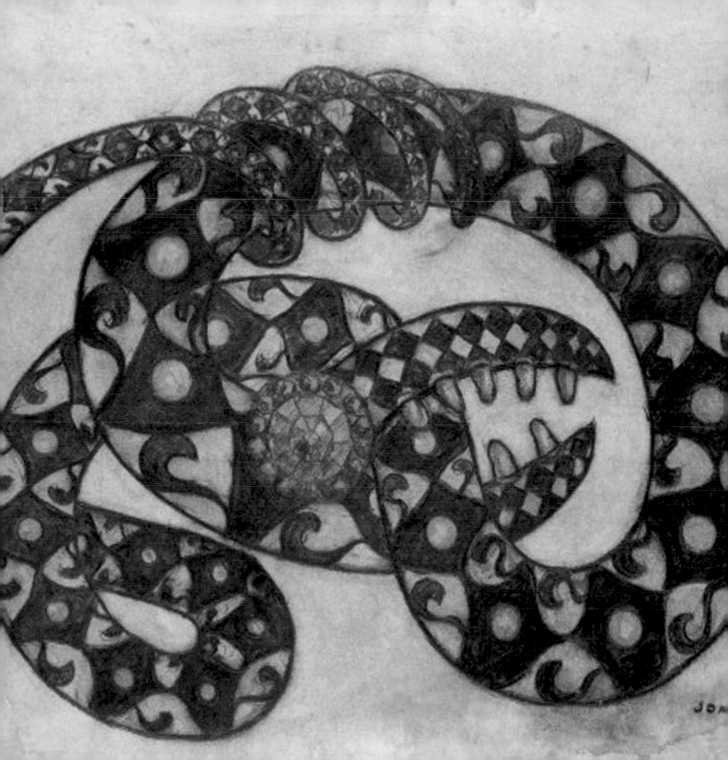

LINE

line

MOON

moon

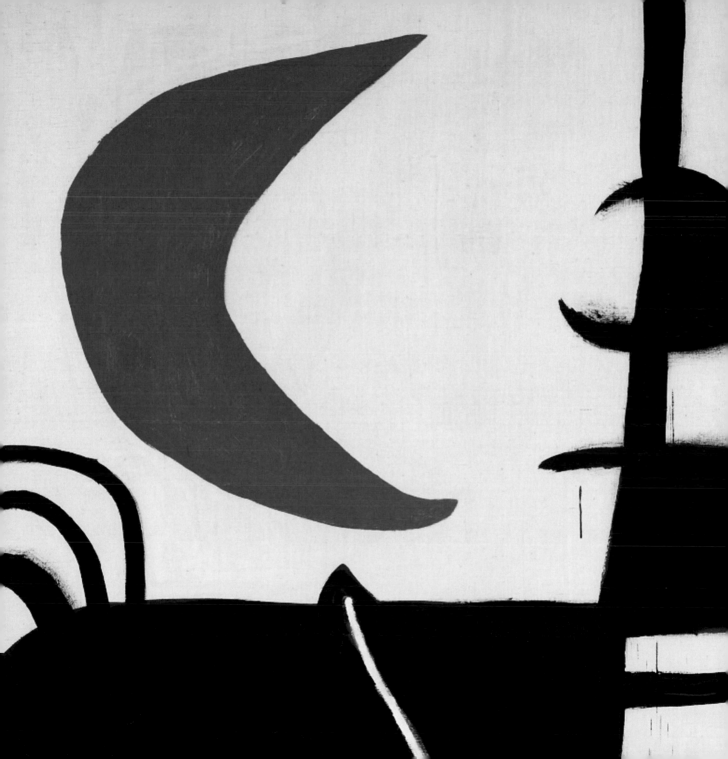

NIGHT

night

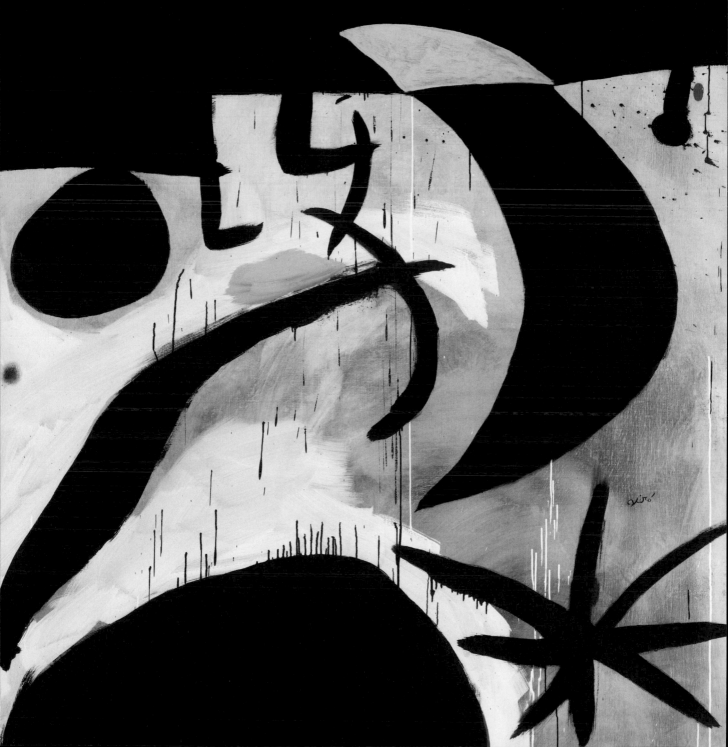

OVAL

oval

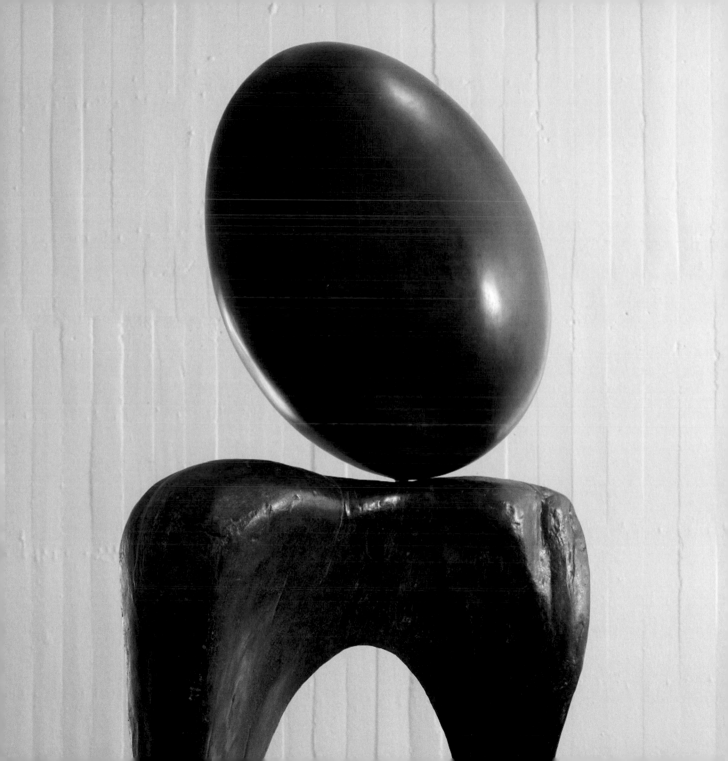

PERSONAGE

personage

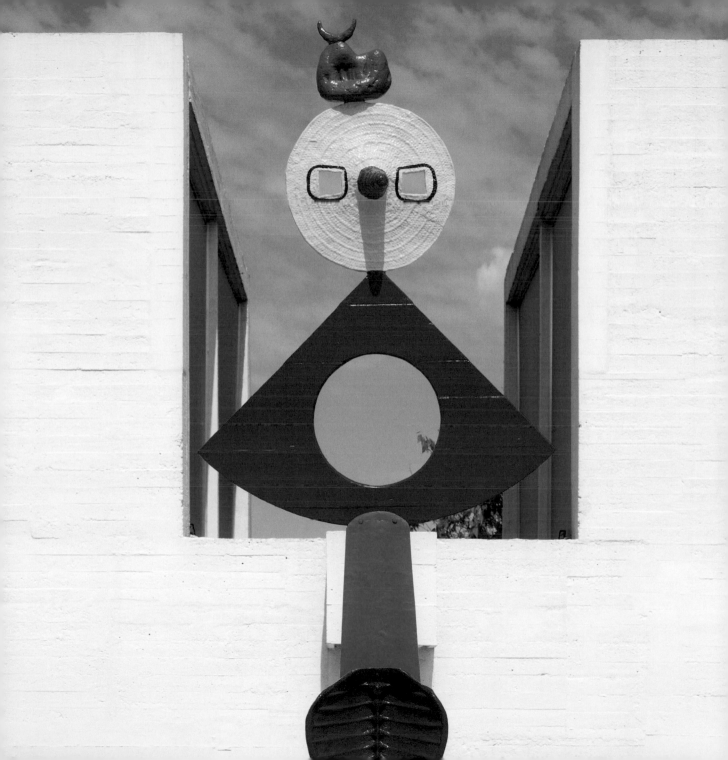

SQUARE

square

RED

red

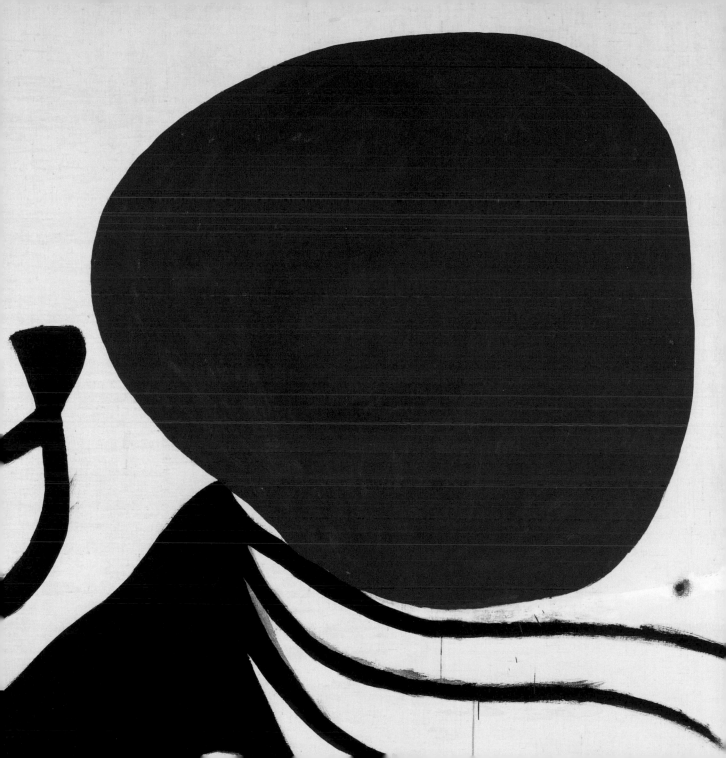

STAR

star

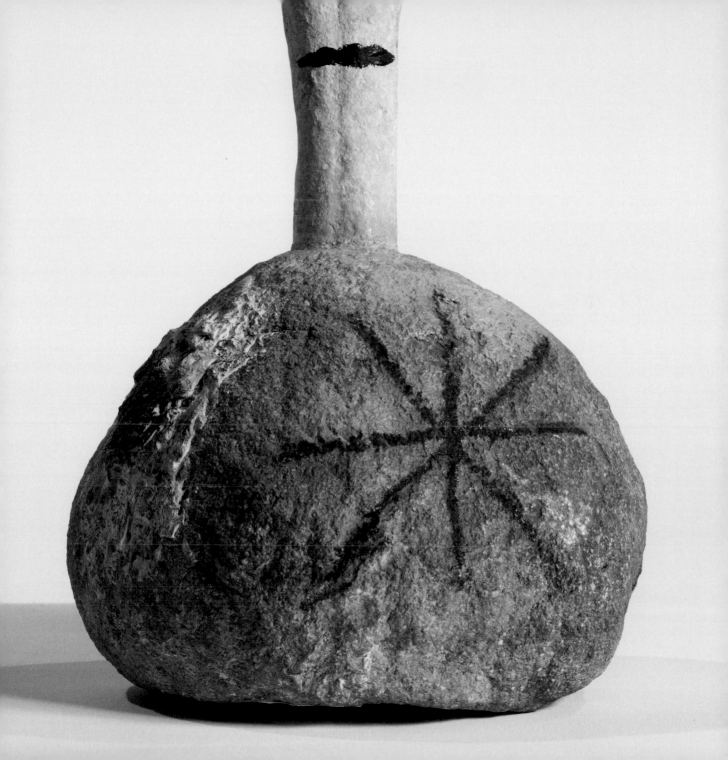

TAPESTRY

tapestry

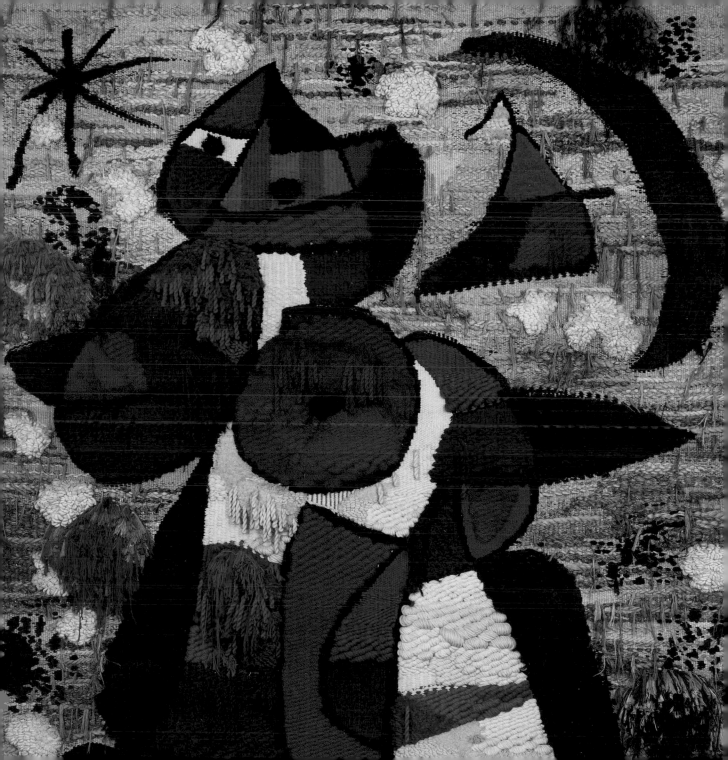

UNIVERSE

universe

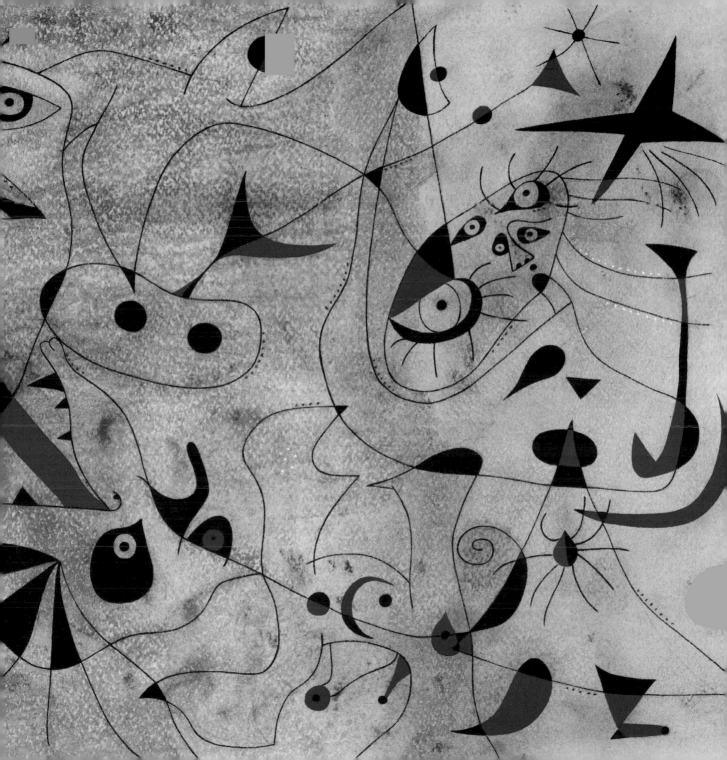

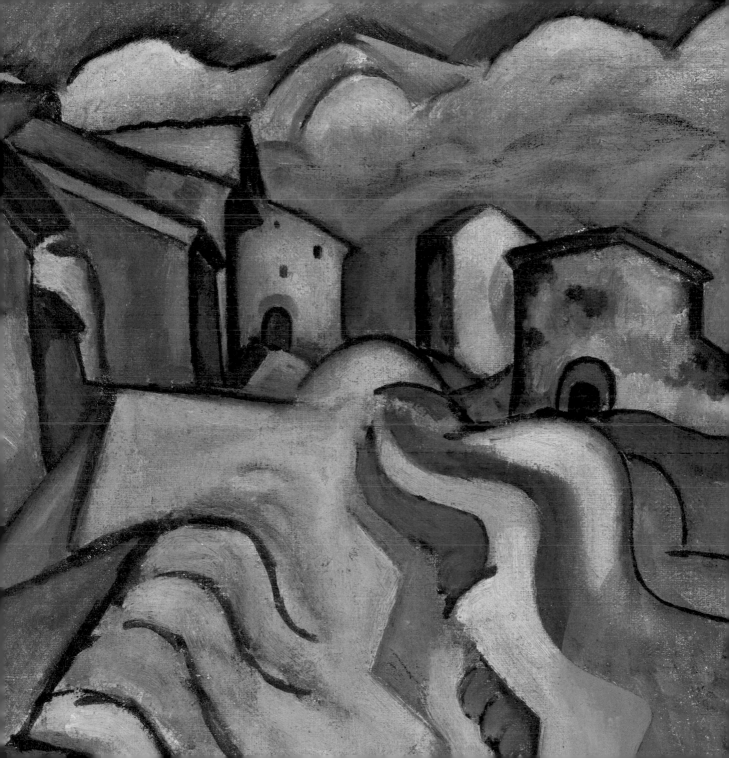

WOMAN

woman

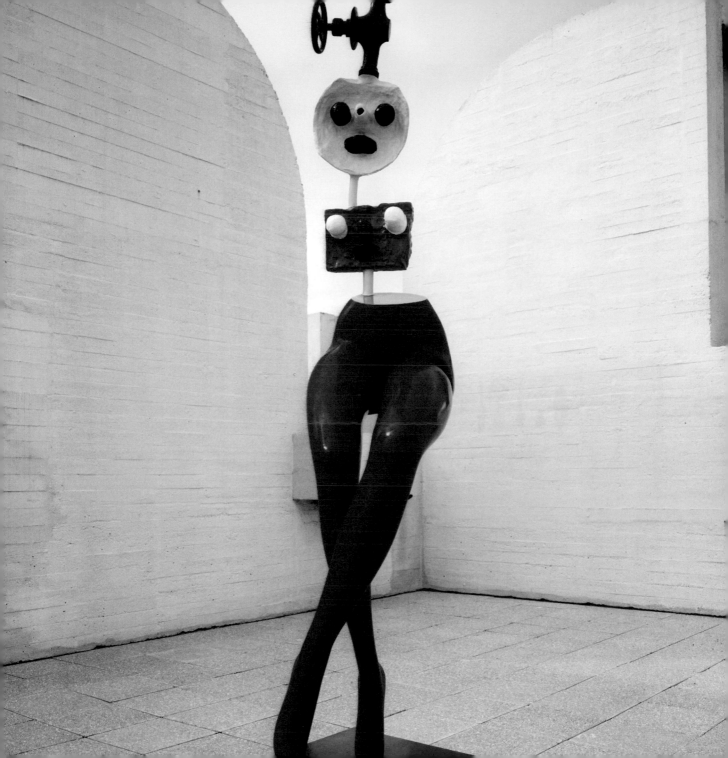

TEXT

text

JOAN MIRÓ

l'été

Une femme brûlée par les
flammes du soleil attrape un papillon qui s'
envole poussé par le souffle d'une fourmi se
reposant à l'ombre arc-en-ciel
du ventre de la femme devant la mer
les aiguilles de ses seins tournées vers
les vagues qui envoient un sourire blanc

Y

YELLOW

yellow

Gemma París Romia Artist and professor of Art Education at the Faculty of Education of UAB Barcelona; PhD in Fine Art from the University of Barcelona. She has been awarded numerous visiting artist grants for stays in Mexico City, London, Paris and Argentina which have allowed her to carry out her artistic work in new settings, in addition to showing her work in numerous institutions and galleries in cities such as Barcelona, Paris, Madrid, Lleida and Milan. gemma.paris@uab.cat

Mar Morón Velasco Professor of Art Education at the Faculty of Education of UAB Barcelona; Artist, PhD in art education and creator of artistic projects for schools and museums for persons requiring special needs. Lines of research: Education through Art, Art education, and Special Education. Author of website: *L'art del segle xx a l'escola*. mar.moron@uab.cat

As **artists**, we see art as an enriching experience which should be made accessible to everyone,

as **teachers**, we want art to be an enlivening part of the school setting,

as **educators**, we love to accompany the youngest among us on their fantastic adventure in learning to read texts and images,

as **researchers**, we develop new ways of building bridges between art and education,

as **adults**, we are interested in offering people suggestive images and words that will allow their imagination to run free

as **girls**, we would like to thank those individuals who gave us the opportunity to participate in aesthetic and creative experiences starting at a very young age and...

as **women with families of our own**, we are motivated when a child uses their curiosity to learn through art.

P. 57
Flama en l'espai i dona nua
(Flame in space and naked
woman), 1932
Painting. Oil on cardboard
41 × 32 cm
Fundació Joan Miró, Barcelona
Gift of Joan Prats

P. 59
Femme rêvant de l'évasion
(Woman dreaming of escape),
1945
Painting. Oil on canvas
130 × 162 cm
Fundació Joan Miró, Barcelona

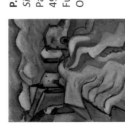

P. 47
Tapestry of the Foundation, 1979
Wool and natural fibres
750 × 500 cm
Fundació Joan Miró, Barcelona

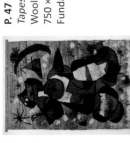

P. 49
L'étoile matinale
(Morning star), 1940
Painting. Gouache and oil wash
on paper
38 × 46 cm
Fundació Joan Miró, Barcelona
Gift of Pilar Juncosa de Miró

P. 51
Siurana, the village, 1917
Painting. Oil on canvas
49 × 39 cm
Fundació Joan Miró, Barcelona.
On loan from private collection

P. 53
Jeune fille s'évadant
(Young girl escaping), 1967
Sculpture. Painted bronze
216 × 50 × 56 cm
Fundació Joan Miró, Barcelona

P. 55
L'été
(Summer), 1937
Drawing-Poem. Indian ink on card
39,1 × 31,6 cm
Fundació Joan Miró, Barcelona

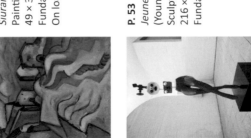

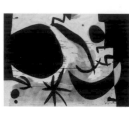

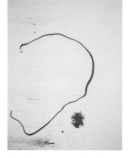

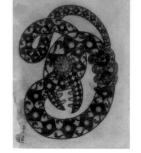

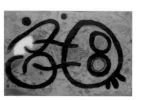

P. 27
Autoportrait,
(Self-portrait), 1937-1960
Painting. Oil and pencil on canvas
146,5 × 97 cm
Fundació Joan Miró, Barcelona
On loan from private collection

P. 29
Snake, 1908
Drawing. Graphite pencil and charcoal
on paper
48,5 × 63 cm
Fundació Joan Miró, Barcelona

P. 31
L'espoir du condamné à mort I
(The hope of a condemned man I), 1974
Painting. Acrylic on canvas
267 × 351 cm
Fundació Joan Miró, Barcelona

P. 33
Femme devant la lune II
(Woman in front of the moon II), 1974
Painting. Acrylic on canvas
269,5 × 174 cm
Fundació Joan Miró, Barcelona

P. 35
Femme et oiseaux dans la nuit
(Woman and birds in the night),
1969-1974
Painting. Acrylic on canvas
243,5 × 173,8 cm
Fundació Joan Miró, Barcelona

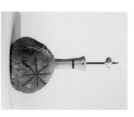

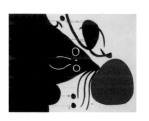

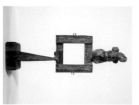

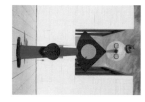

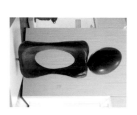

P. 37
Monument à la femme
(Woman, Monument), 1970
Sculpture. Bronze
250 × 95 × 60 cm
Fundació Joan Miró, Barcelona

P. 39
La caresse d'un oiseau
(The caress of a bird), 1967
Sculpture. Painted bronze
311 × 111 × 38 cm
Fundació Joan Miró, Barcelona

P. 41
Personage, 1971
Sculpture. Bronze
79 × 30 × 20 cm
Fundació Joan Miró, Barcelona

P. 43
Femme devant le soleil I
(Woman in front of the sun I), 1974
Painting. Acrylic on canvas
258,5 × 194 cm
Fundació Joan Miró, Barcelona

P. 45
Project for a monument, 1951
Sculpture-object. Stone, bone,
gouache, oil, porcelain hook and iron
45 × 20 × 14 cm
Fundació Joan Miró, Barcelona

P. 17

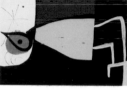

Femme dans la nuit
(Woman in the night), 1973
Painting. Acrylic on canvas
195 × 130 cm
Fundació Joan Miró, Barcelona
Gift of Pilar Juncosa de Miró

P. 19

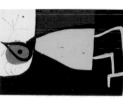

Le placeur du music-hall
(The music-hall usher), 1925
Painting. Oil on canvas
100 × 78 cm
Fundació Joan Miró, Barcelona
On loan from the Generalitat de
Catalunya

P. 21

Portrait of a young girl, 1919
Painting. Oil on paper on canvas
34,8 × 27 cm
Fundació Joan Miró, Barcelona
Gift of Joan Prats

P. 23

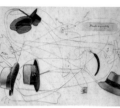

Homage to Joan Prats, 1934
Collage-drawing. Collage,
graphite pencil and
charcoal on paper
63,3 × 47 cm
Fundació Joan Miró, Barcelona
Gift of Joan Prats

P. 25

The bottle of wine, 1924
Painting. Oil on canvas
73,5 × 65,5 cm
Fundació Joan Miró, Barcelona
On loan from private collection

P. 5

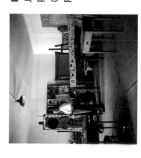

Joaquim Gomis: Joan Miró in his atelier
Passatge del Crèdit, 1944
© Hereus de Joaquim Gomis
Fundació Joan Miró, Barcelona

P. 9

L'étoile matinale,
(Morning star), 1940
Painting. Gouache and oil wash on paper
38 × 46 cm
Fundació Joan Miró, Barcelona
Gift of Pilar Juncosa de Miró

P. 11

Oiseau solaire
(Solar bird), 1968
Sculpture. Carrara marble
163 × 146 × 240 cm
Fundació Joan Miró, Barcelona
Gift of Marguerite and Aimé Maeght

P. 13

Femme et oiseau devant le soleil
(Seated woman and child), 1967
Sculpture. Painted bronze
123 × 39 × 40 cm
Fundació Joan Miró, Barcelona

P. 15

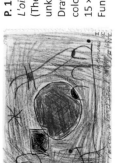

L'oiseau se lance vers l'inconnu
(The bird throws itself into the
unknown), 1967
Drawing. Graphite pencil, pen and
coloured crayons on paper
15 × 20,7 cm
Fundació Joan Miró, Barcelona

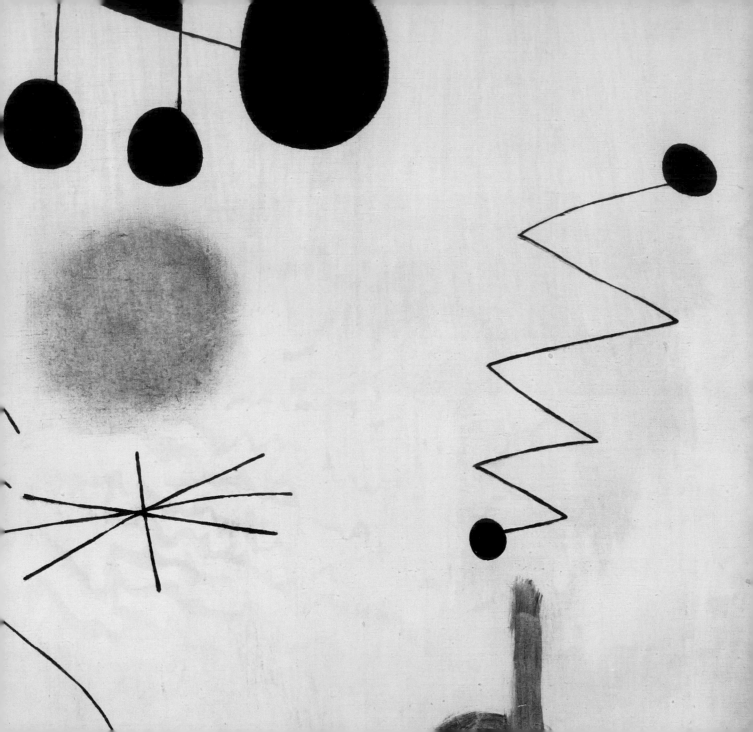

ZIGZAG

zigzag

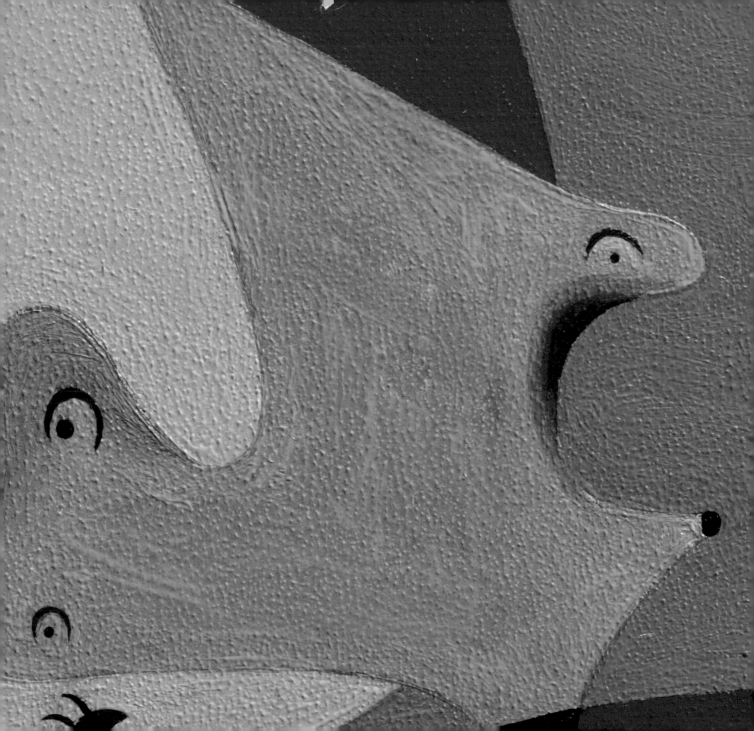